1

THE BRITISH MUSEUM

BUDDHA

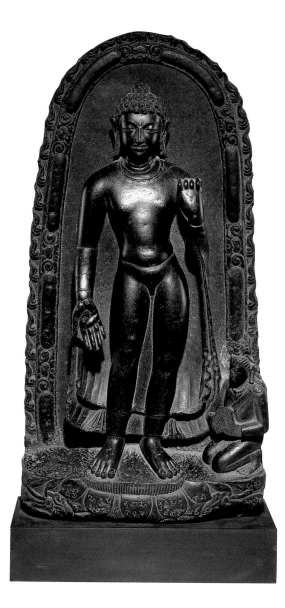

THE BRITISH MUSEUM

BUDDHA

DELIA PEMBERTON

THE BRITISH MUSEUM PRESS

Thanks to Richard Blurton and Stephen Ruscoe of The British Museum Department of Oriental Antiquities and to John Feuille of the Foundation for the Preservation of the Mahayana Tradition.

Photography by The British Museum Department of Photography and Imaging With additional photographs by Graham Harrison and Delia Pemberton Line motif of the Wheel of the Law by Ann Searight

First published in 2002 by The British Museum Press
A division of The British Museum Company Ltd
46 Bloomsbury Street, London WCIB 3QQ

A catalogue record for this book is available from the British Library

ISBN 0 7141 2407 9

Designed and typeset in Centaur by Peter Ward
Printed in Hong Kong by C&C Offset

Frontispiece: Schist figure of Shakyamuni Buddha
from Sultanganj, India, 7th–8th century AD
Opposite: The Great Buddha at Bamiyan, Afghanistan,
in AD 1978, before its destruction in March 2001

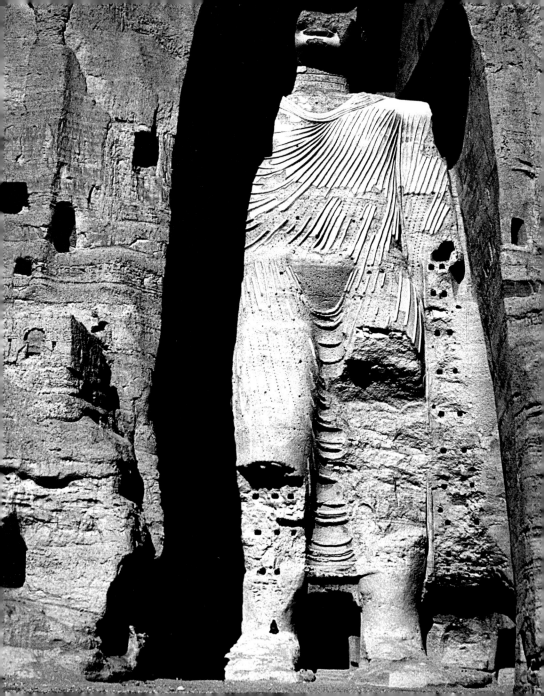

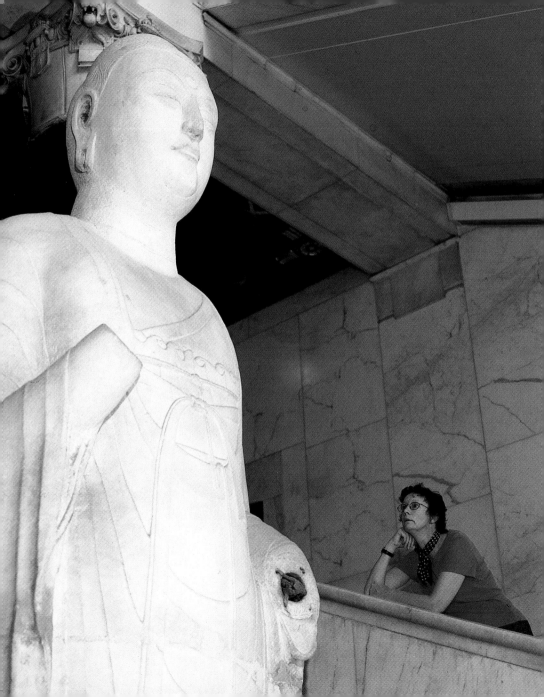

INTRODUCTION

FOR TWO THOUSAND YEARS artists have created images of the Buddha. In shrines, temples, monasteries and private homes around the world Buddha images are regarded as living presences, honoured with prayers and offerings as an expression of gratitude to the Buddhas for their teaching and in recognition of the worshipper's own spiritual potential.

Even those unversed in the Buddhist teachings find themselves moved and inspired by Buddha images, hence their long popularity among Western art lovers and collectors. The British Museum cares for one of the greatest collections of Buddhist art in the world. However, it is important to remember that these images were never intended as art, to be displayed in museums or galleries, but to serve as objects of public and private devotion for followers of the Buddhist path.

This book offers ways of approaching Buddha images by examining why and for whom they were made and what they were meant to convey. The wide variety of images, drawn from many times and places, gives a glimpse of the breadth and beauty of the Buddhist vision.

We say that for a Buddhist practitioner the function [of objects] is to support faith, because they encourage the aspiration to acquire the qualities the images represent.
HH 14th Dalai Lama

Colossal white marble figure of the Buddha Amitabha
from the Chongguang Temple in Hebei province, China,
7th century AD

THE BUDDHA

FEW FACTS ARE KNOWN about the historical Buddha, Siddhartha Gautama, also known as Shakyamuni, who lived in the Indian subcontinent during the sixth to fifth centuries BC and founded the faith we now know as Buddhism. Addressing the eternal question of human suffering, the Buddhist teachings offer an explanation for the origins of suffering and a path by which it may be transcended to attain liberation, or nirvana. The Buddha's teaching is summarized in what are known as the Four Noble Truths:

Everything is suffering
The origin of suffering is desire
There exists Nirvana, an end to suffering
A path, defined by the Buddha, leads to Nirvana

On being asked about the nature of a Buddha, Shakyamuni once replied, 'A Buddha is reality'. Another tradition tells of a traveller, impressed by his peaceful presence, who enquired: 'Are you a god?' 'No,' the Buddha replied, 'I am not a god'. 'A spirit, then?' 'No, I am not a spirit.' 'Are you a man?' 'No, I am not a man.' 'Then what are you?' 'I am awake.' A Buddha is 'awake' to the true nature of existence and thereby free of its sufferings — and the purpose of Buddhist teachings and art is to point the way to awakening for all.

Head of a lacquered wood figure
of Amitabha Buddha from Japan,
13th century AD

8

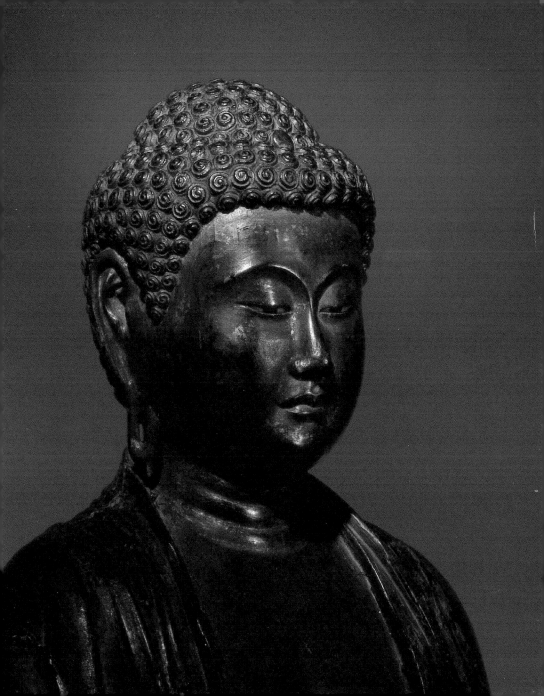

THE BUDDHIST VISION

BUDDHISM VIEWS THE WORLD we perceive as an illusion, in which all phenomena are subject to change, growth and decay. In accordance with the law of cause and effect, or karma (literally, 'action'), the individual consciousness, or soul, is propelled into an endless series of reincarnations. The workings of this cyclical existence, samsara, are illustrated by the Wheel of Life.

This huge wheel, held by a terrifying monster, is divided into three concentric circles. At its hub are a cock, a snake and a pig, representing greed, anger and ignorance – the driving forces that keep the whole system in motion. Around this are six segments representing the realms of cyclical existence into which beings are born according to their karma. In the bottom half are the three lower realms, belonging to the animals, hungry ghosts and hell-beings, and in the top are the three higher realms, those of humans, gods and titans. The rim of the wheel is divided into twelve sections known as the 'Links of Interdependent Origination' – showing exactly how the cycle of samsara operates, beginning with ignorance and ending with death.

Liberation from this cycle (nirvana) can only be achieved by purifying one's karma through mental, physical and spiritual discipline, to the point where one can no longer be deceived by the illusory nature of existence. The possibility of escape is indicated by the Buddha who, already free from the cycle, stands outside the wheel.

Painted textile (thangka) from Tibet,
19th century AD

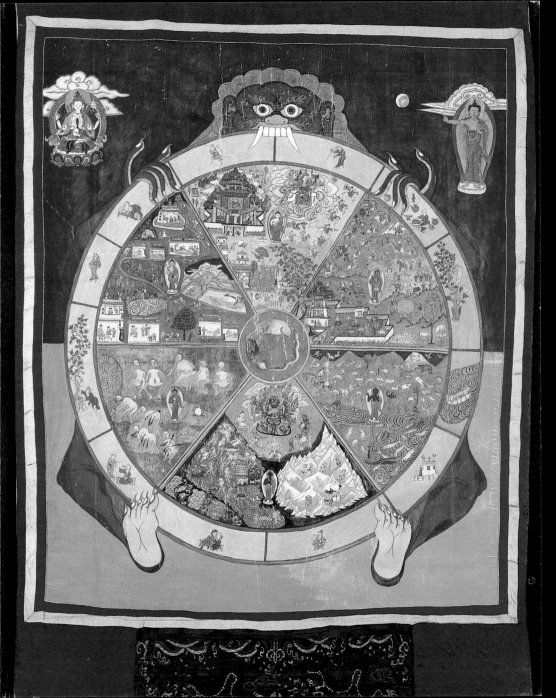

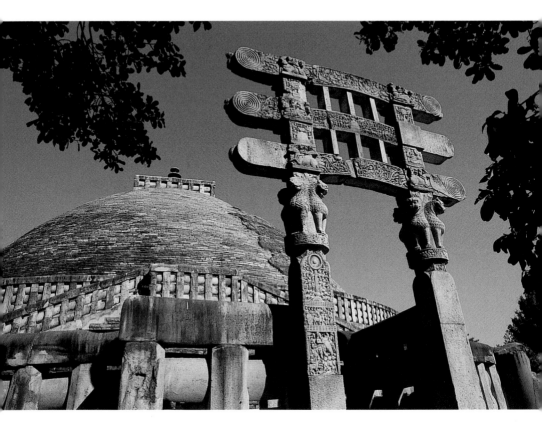

Buddhist stupa at Sanchi, India,
1st century BC

ILLUSTRATING THE TEACHINGS

BUDDHIST ART DEVELOPED from the wish to extend the abstract and sometimes complex teachings of Buddhism to a wider audience. The visual arts were an ideal medium of communication. Although most ordinary people were illiterate, they were steeped in the artistic traditions of the Indian subcontinent and extremely familiar with the subtle symbolic language of religious iconography. Images that drew on these traditions were therefore produced in order to provide Buddhist worshippers with an identifiable focus for their devotion. Many Indian Buddha images are thus reminiscent of Hindu and Jain art produced at the same time.

After the death of the historical Buddha, his physical remains were cremated and divided among the faithful, who interred them in funerary monuments known as stupas. The stupa developed from the traditional domed burial mound of the Indian subcontinent. In its earliest form it comprised a hemispherical mound set on a base, surrounded by a processional path and surmounted by a railing enclosing a pillar and parasols. The stupa itself became one of the most important Buddhist symbols, representing the Buddha's mind and the perfection he attained in his final departure from this life.

THE AMARAVATI STUPA

STUPAS WERE THE FIRST PLACES of pilgrimage for the Buddhist faithful, who paid respect to the Buddha and his teachings by processing around them in a clockwise direction. From the first century AD, statues and reliefs were added to the outside of stupas so pilgrims could study and reflect on them while following the ceremonial route.

This carving from the stupa at Amaravati in India shows the stupa itself, enclosed by a railing and guarded by stone lions, the sky above thronged with celestial worshippers. The outside of the monument is covered in elaborate reliefs showing scenes from the Buddha's life, and at the entrance pilgrims can be seen praying and making offerings to a standing Buddha figure.

Inscriptions at the site of Amaravati associate the foundation of the stupa with the Indian king Ashoka, who established a Buddhist empire throughout much of the subcontinent in the third century BC.

Limestone drum slab from
the Amaravati stupa, India,
3rd century AD

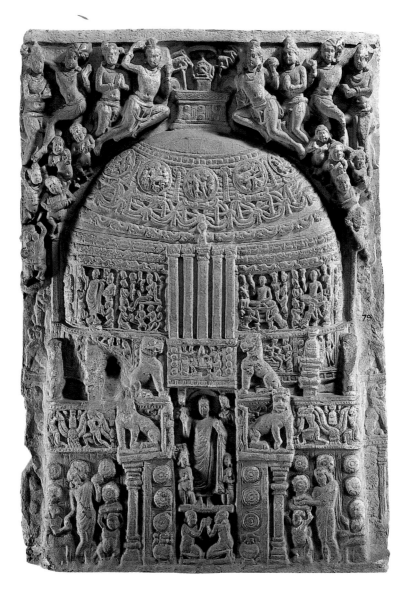

15

BUDDHA SYMBOLS

T HE EARLIEST BUDDHIST ART avoided showing the Buddha in human form, but instead indicated his presence through symbols such as the stupa, stylized footprints or the wheel, representing the Buddhist law, or Dharma. Reflecting ancient beliefs in mystical signs and symbols, the hands and feet of Buddhas are distinguished by special markings.

These Buddha feet (buddhapada) from Amaravati can be identified by the fact that the toes are of equal length, one of the physical characteristics of a Buddha. At the centre of each foot is a many-spoked Dharma wheel, while at the heel is a 'Triple Jewel' (triratna) representing the Three Jewels of Buddhism: the Buddha, his teaching (the Dharma) and the spiritual community (the Sangha). At the front is a large swastika, an auspicious symbol – the term svasti means 'all is well'. Each big toe is decorated with the Triple Jewel, the smaller toes with swastikas.

Limestone slab from the
Amaravati stupa, India,
1st century BC

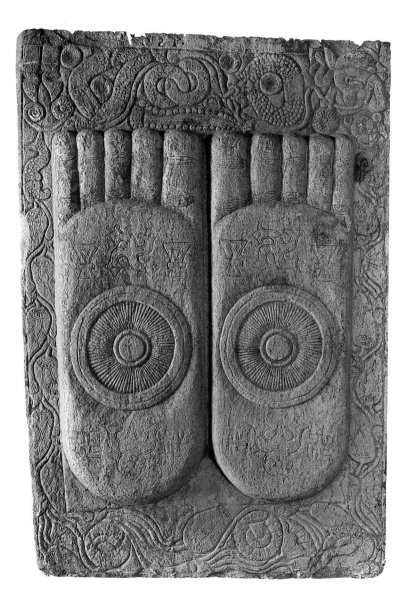

REPRESENTING THE BUDDHA

SOME OF THE EARLIEST human images of the Buddha were made in the ancient kingdom of Gandhara, an area spanning parts of modern Pakistan and Afghanistan. Gandharan Buddha images are characterized by wavy hair, youthful features and classical-style draped robes, reflecting the strong influence of Greek and Roman art on this region.

Made in the first century AD, this golden reliquary was found inside a stone casket from a stupa; an inscription records that it originally contained fragments of the Buddha's bones. The exterior shows Shakyamuni Buddha flanked by the gods Indra and Brahma, a reminder of Buddhism's roots in the religious traditions of the Indian sub-continent. The Buddha is distinguished by his monastic robes and the aureole or halo indicating holiness.

Cease to do evil, learn to do good, and purify your mind.
This is the teaching of the Buddhas.
Dhammapada

Gold reliquary, set with garnets,
from a stupa at Bimaran, Afghanistan,
1st century AD

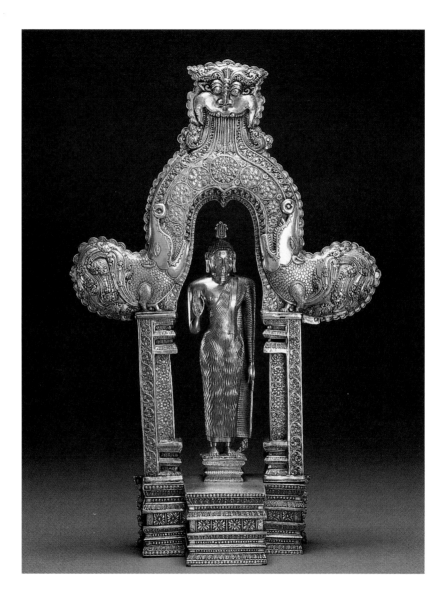

THE BUDDHA IMAGE

I MAGES OF THE BUDDHA can be identified by distinctive physical characteristics, postures and hand gestures. The unique physical features of a Buddha are known by the Sanskrit term lakshana. The most conspicuous are the ushnisha, a cranial bump indicating special wisdom; the urna, a round tuft of hair between the eyebrows, indicating supernatural vision; short curled hair, indicating the renunciation of worldliness; and long pierced earlobes, indicating nobility (ancient Indian royalty wore huge heavy earrings that stretched the lobes). The ushnisha sometimes takes the form of a flame, indicating illumination. A Buddha's expression is always serene, the eyes half-closed in meditation and a gentle smile on the lips.

The Buddha may also be shown in various postures (asanas), which can be divided into sitting, standing and reclining poses. The seated postures indicate stillness, as in meditation; the standing postures are more dynamic and are associated with action; the reclining posture refers exclusively to the Buddha's physical death (parinirvana).

Hand gestures (mudras) indicate a specific activity such as teaching, meditating or offering reassurance. Each of these postures and gestures has its own significance, some referring to specific incidents in the life of the historical Buddha. In this standing Buddha figure from Sri Lanka, the Buddha's right hand is raised, palm outwards, with the thumb and forefinger together in the gesture of discussing the Dharma (vitarka mudra).

Silver and silver-gilt figure
from Sri Lanka,
18th century AD

Overleaf: The Shwethalyaung
reclining Buddha at Pegu, Burma

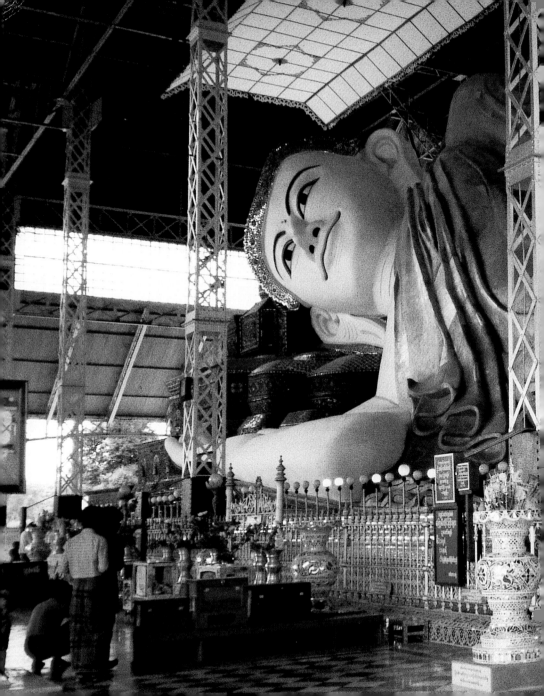

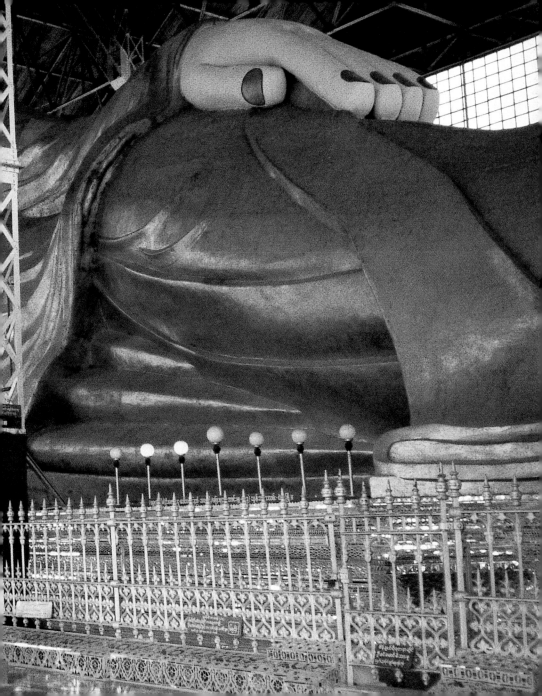

BUDDHAS OF THE PAST

SHAKYAMUNI, THE HISTORICAL BUDDHA, is regarded by all schools of Buddhism as the Buddha of the present age. However, since all beings are considered to have the potential to achieve Buddhahood, many Buddhist traditions also recognize Buddhas of the past and future.

Buddhist cosmology, drawing on ancient Indian traditions, divides time into kalpas, or ages, in each of which the universe completes a cycle of creation and destruction. Each age sees the appearance of at least one Buddha who reveals the Buddhist teachings to the beings of that age. This revelation is known as 'Turning the Wheel of the Law'.

The innumerable past Buddhas of the present age, known collectively as the 'Thousand Buddhas' or 'Ten Thousand Buddhas', are worshipped under that name at sites such as the cave temples of Dunhuang and Longmen in China. Only a few of these Buddhas are given names: these include Prabhutaratna, who represents the embodiment of all the Buddhas of the past; Dipankara, whose name means 'Creator of Light'; and Kashyapa, the immediate predecessor of Shakyamuni.

Follow the wise, the intelligent and the awakened.
Follow them as the moon follows the path of the stars.
Dhammapada

Buddha images in the Cave of
the Ten Thousand Buddhas
at Longmen, Luoyang, China

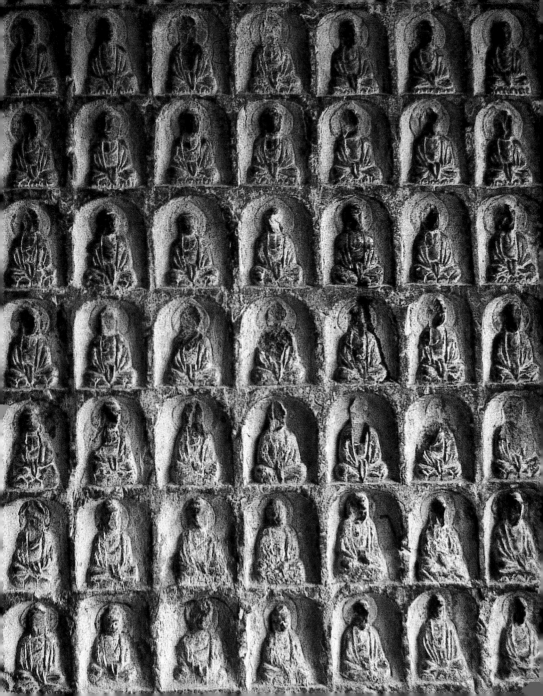

DIPANKARA
AND THE BODHISATTVA

THERE IS A TRADITION that each Buddha is confirmed by his predecessor. This painting from Dunhuang, China, shows how Dipankara Buddha prophesied the future Shakyamuni's Enlightenment when he was a young man in one of his previous lives.

Reincarnated in the time of Dipankara as a Brahmin, or priest, the future Buddha had already formed the intention to attain perfection for the benefit of suffering beings. Learning that Dipankara was nearby, he resolved to pay honour to the Buddha and affirm his resolve before him. He begged some flowers from a young woman and threw them at the feet of the Buddha in homage. Then, prostrating himself on the ground, he spread out his long hair for Dipankara to walk upon. Pleased with the young man's humility and sincerity, Dipankara accepted his vow and prophesied that he would indeed attain Enlightenment and become a Buddha.

One destined to become a Buddha is called a Bodhisattva – literally, one possessed of the essence (sattva) of Enlightenment (bodhi). A Bodhisattva is a being who has spontaneously generated the motivation to benefit all sentient beings by bringing them to Enlightenment.

As long as space endures,
And as long as sentient beings exist,
May I too remain
And dispel the miseries of the world.
BUDDHIST PRAYER

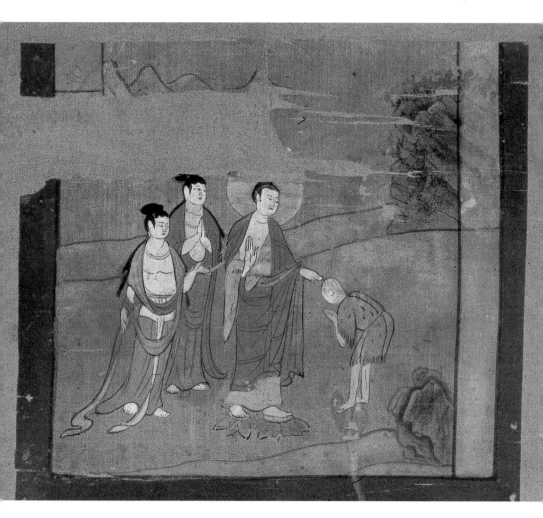

Detail of a silk painting from Cave 17,
Dunhuang, China, Tang dynasty, 9th century AD

JATAKA STORIES

TALES OF SHAKYAMUNI's previous incarnations, known as Jataka
stories, are popular subjects for reliefs at stupas and other religious
sites, where they serve to illustrate the ideals of Buddhist conduct. The
story of King Shibi, shown in this relief from Gandhara, demonstrates
the principles of generosity, non-violence and equanimity — equal care
for all beings.

Incarnated as the king Shibi, the future Shakyamuni was sitting in his
court one day when a dove flew into the room, closely pursued by a hawk.
The dove begged Shibi's protection, and having vowed not to harm any
being who requested his help, the Bodhisattva immediately agreed.

But the hawk remonstrated with Shibi, arguing that by protecting
the dove he had deprived him of his legitimate prey. Shibi acknowledged
the truth of this, but could not go back on his promise to the dove. Shibi
then asked the hawk if he would accept the equivalent amount of flesh
from his own body. The hawk agreed, and scales were fetched.

Shibi began to cut slices of his own flesh and place them in the
scales. But however much flesh was added, it did not equal the weight of
the dove. Not until Shibi, reduced to a skeleton, was on the verge of
death did the scales balance. At this moment, the hawk revealed himself
as the god Indra, who had taken this disguise to test the Bodhisattva's
resolve, and the dove as another god, Vishvakarma. Shibi was healed.

Here Shibi is shown seated on the left of the scene, with the dove at
his feet. In the centre is an attendant with a balance and above him the
damaged figure of the hawk. Indra and Vishvakarma appear on the right.

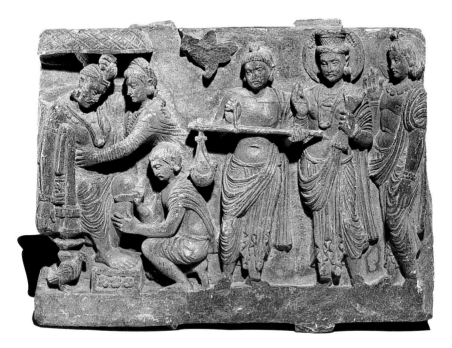

Schist panel from Gandhara, Pakistan,
2nd–3rd century AD

29

THE INCARNATION
OF THE BUDDHA

LIKE THAT OF MANY GREAT religious figures, the conception of the future Shakyamuni Buddha was believed to have been attended by miraculous events. His father Shuddhodana, a local ruler, and his mother, Maya, belonged to the noble clan of the Shakyas. One night Maya had a wonderful dream in which a white elephant entered the right side of her body. In this silk painting from Dunhuang, China, the future Buddha is shown as a naked infant on the back of the white elephant.

The next morning Maya related this dream to her husband, who summoned eight Brahmin priests to interpret it. All agreed that it was an excellent omen, and prophesied that Maya would bear a child destined either to attain perfect wisdom or to become a world conqueror.

As a mother watches over her child, willing to risk her own life to protect her only child, so with a boundless heart should one cherish all living beings, suffusing the whole world with unobstructed loving kindness.
Metta Sutta

Detail of a silk painting from Cave 17,
Dunhuang, China, Tang dynasty,
9th century AD

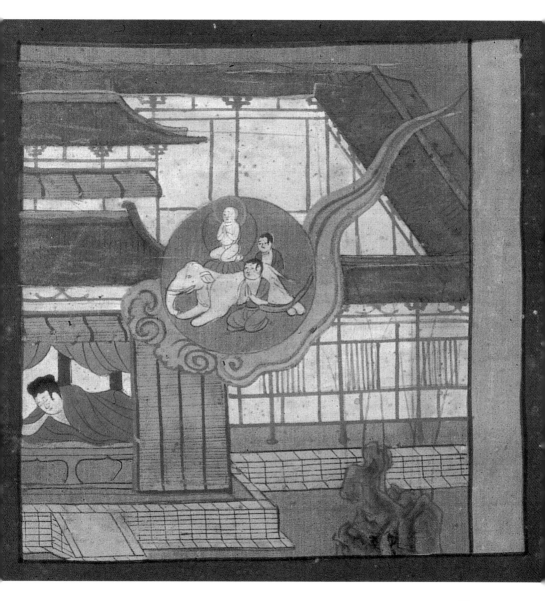

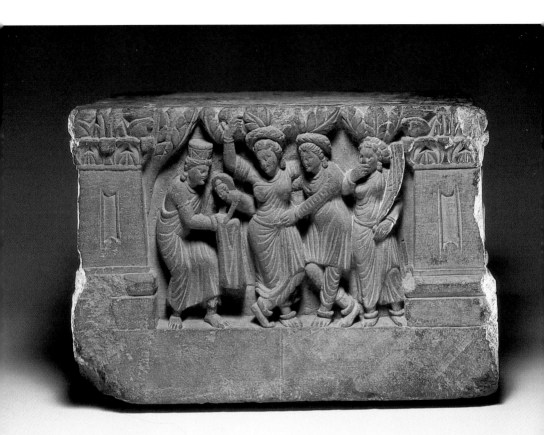

Grey schist block from Gandhara,
Pakistan, 2nd–3rd century AD

BIRTH OF THE BUDDHA

THIS RELIEF FROM GANDHARA narrates the story of the future Buddha's birth. When the time of Maya's confinement drew near, her father grew anxious that she might die in childbirth and asked her husband Shuddhodana to allow her to come to his home adjoining the Lumbini gardens. As soon as she arrived, she walked over to a tree which immediately bent down to her. Taking hold of a branch, she looked up to heaven, and at that moment the future Buddha was born from her right side. The god Indra, shown here with a tall headdress, appeared to receive him.

Then, without any help, the child took seven steps in the direction of each of the cardinal points and announced in a clear voice: 'I will have no further births to endure, for this is my last body. Now I shall destroy and pluck out by the roots the sorrow that is caused by birth and death.' On hearing of this miracle, Shuddhodana named the child Siddhartha, meaning Perfect Fulfilment. He also received the family name Gautama. In later times he became known simply as Shakyamuni – the 'Sage of the Shakyas'.

THE THREE SIGHTS

WHEN THE EIGHT BRAHMINS were told of the omens that had attended Siddhartha's birth, they advised Shuddhodana that the child would become either a great king or a great religious teacher. Not wishing to lose his only son to the religious life, Shuddhodana resolved to fill his days with luxury and pleasure and shield him from anything that might turn his mind to introspection.

But as he grew into a young man Siddhartha felt restless, despite all the pleasures of the palace. He began to make journeys around the city and out into the countryside, always accompanied by his faithful groom, Channa. On these occasions, Shuddhodana was careful to ensure that all lame, blind, sick and elderly people were kept out of sight. Nevertheless, the young prince saw in turn an old man, a sick man and a corpse. Channa explained what Siddhartha had never before realized – that all beings are subject to the sufferings of ageing, sickness and death. In this silk painting from Dunhuang, China, the 'Three Sights' are represented by an old man: first shown supported by a boy, then on his sickbed and finally as a corpse, his soul flying up to heaven.

On their next journey, they met a wandering ascetic with a shaven head, wearing a saffron robe and carrying a pilgrim's staff and beggar's bowl. Siddhartha was curious and asked him who he was. The man explained that he had renounced his home and family and was practising penances in order to find liberation from the sufferings of existence. The prince was deeply moved and filled with respect. From this moment, he resolved to seek out the source of suffering and to overcome it.

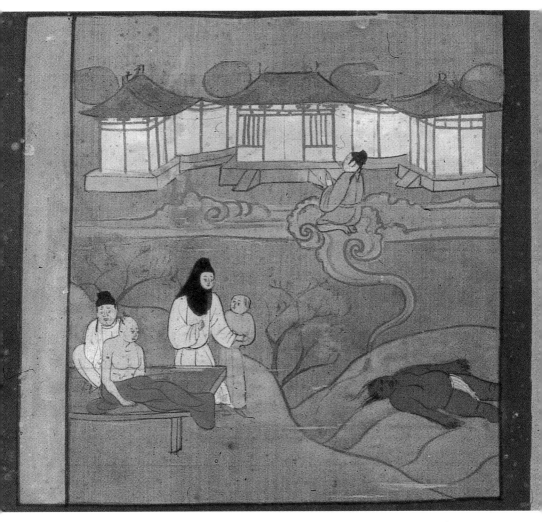

Detail of a silk painting from Cave 17, Dunhuang, China,
Tang dynasty, 9th century AD

THE GREAT DEPARTURE

FOLLOWING THESE ENCOUNTERS, Siddhartha became filled with a deep compassion for his fellow beings and a great longing to help them overcome their suffering. He was convinced that the only way to do this was to follow the ascetic's example – renouncing worldly attachments, leaving his home and family and becoming a wandering yogi. One night, leaving his wife Yashodara and son Rahula asleep, he crept out of the palace. He mounted his favourite stallion, Kanthaka, and, accompanied only by the faithful Channa, made his way to the river that marked the boundary of his father's lands.

There, at the edge of the jungle, he dismounted, cut off his long hair, removed his silken robes and jewelled ornaments and put on a beggar's rags. At the age of thirty he started a new life as a wandering ascetic.

Look at this glittering world, it is like a royal carriage.
The foolish are taken up by it, but the wise do not cling to it.
Dhammapada

Hemp-cloth painting from Korea,
18th century AD

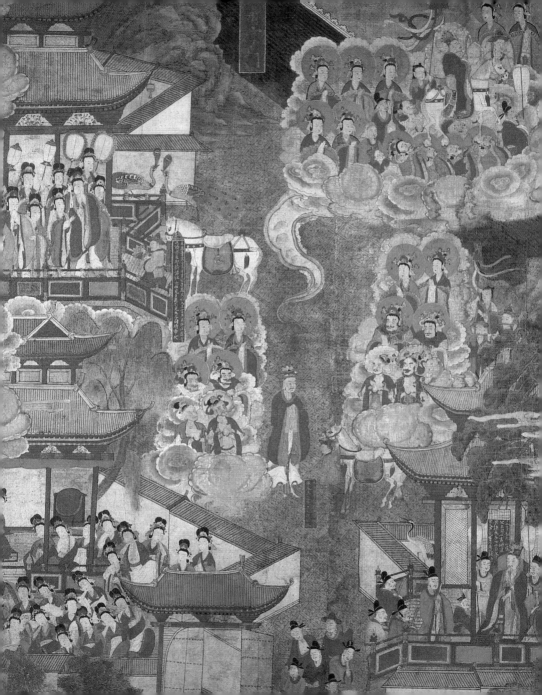

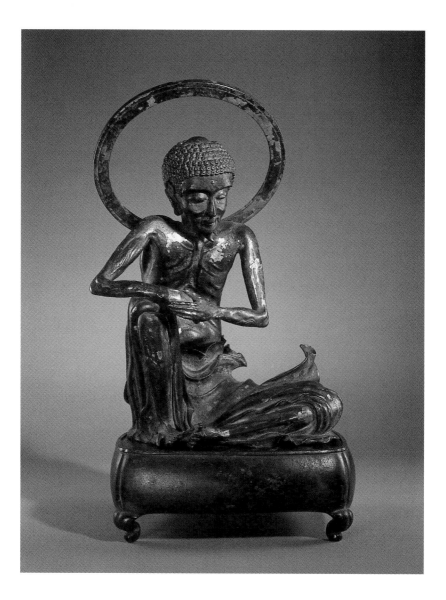

FASTING BUDDHA

Having renounced his former life, Siddhartha travelled from place to place, begging for his food and questioning all the holy men he met about their beliefs and practices. All were seeking the same goal – the complete extinction of mind and body and entry into the state of pure being. Many of these yogis believed that the only way to achieve this was by undergoing terrible penances such as gazing into the sun until their eyes dissolved away, sitting or standing in rigid positions until their limbs became immobile, or starving themselves to the point of death.

Eventually the Bodhisattva went to live in a forest on the banks of the river Nairanjana, where five yogis joined him. For six years he fasted and performed penances, and although these weakened his body, his spiritual powers became strong. His emaciated state is clearly indicated in this Japanese image – the use of lacquer over the gilding refers to a tradition that while fasting his radiant skin became dark.

Eventually, however, it became clear to Siddhartha that extreme physical discipline would not lead to liberation. This could only be achieved by calm meditation – impossible for anyone whose body was worn down by hunger and thirst. He decided to break his fast, and his companions, believing that he had lost his resolve, abandoned him.

Bronze figure, gilded and lacquered,
from Japan, 17th century AD

ENLIGHTENMENT

HAVING REGAINED HIS physical strength, Siddhartha went to the site of Bodh Gaya, where he seated himself under a tree to meditate, vowing not to move until he had attained Enlightenment. During his meditation he was assailed by doubts, temptations and terrifying visions sent by Mara, the personification of desire, but Siddhartha sat unmoved throughout.

Finally Mara himself appeared to taunt him, asking the Bodhisattva to produce evidence of his accumulated merit. In answer, he simply lowered his right hand to touch the earth. At his touch, the earth goddess spoke in a voice like thunder, saying 'I am his witness', and defeated at last, Mara and his armies of demons retired.

The dramatic moment when Siddhartha overcame desire is represented in Buddhist art by the 'touching the earth' gesture (bhumisparsha mudra), in which the Buddha, seated in the meditation posture, lowers his right hand, palm inwards, so that his middle finger touches the earth.

Everywhere clinging to pleasure is destroyed.
The great dark is torn apart.
And Death: you, too, are destroyed.
Therigata

Gilt-bronze figure in Sino-Tibetan style from
China, Ming dynasty, early 15th century AD

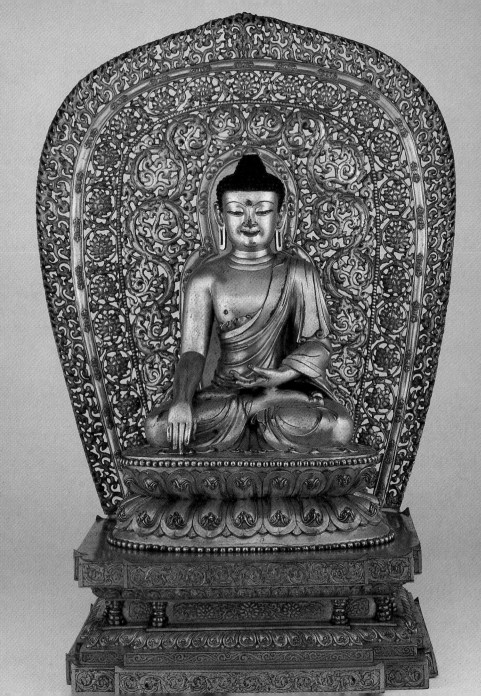

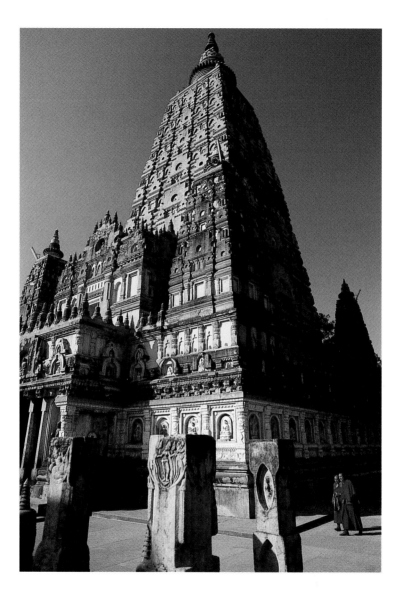

BODH GAYA

HAVING OVERCOME all traces of selfishness and desire, Siddhartha entered a deep meditative state in order to realize the ultimate reality – not merely for his own benefit, but for the sake of all beings. Throughout the night he sat recalling his previous existences, until at dawn he achieved perfect Enlightenment. He had become a Buddha, an 'awakened one'.

For several weeks the Buddha remained in meditation beneath his tree. During this time he was visited by the gods Indra and Brahma, who begged him to share his experience with others for the benefit of those who would understand his teachings.

The Mahabodhi Temple at Bodh Gaya marks the site of the Buddha's Enlightenment and is an important place of pilgrimage for the Buddhist faithful. Although the present building dates from the twelfth century AD and has been restored many times, the original temple is said to have been founded by the emperor Ashoka in the third century BC. A descendant of the original tree under which Shakyamuni meditated still grows in the grounds, and is known as the 'bodhi tree'.

The Mahabodhi Temple
at Bodh Gaya, India

THE FIRST SERMON

WHEN THE BUDDHA finally arose, his first thought was to share his new understanding with the five disciples who had left him in the forest. He found them in a deer park at Sarnath, near Varanasi, where he gave his first teaching in which he set out the doctrine of the Middle Way – the path to Enlightenment that lies between the extremes of excessive physical pleasure and self-inflicted pain.

To follow the Middle Way, one must first accept the Four Noble Truths: that life is suffering; that the root of suffering is desire; that suffering can be ended by uprooting desire; and that the way to uproot desire is by following a path of morality and meditation known as the Noble Eightfold Path. This comprises Right View, Right Intention, Right Speech, Right Action, Right Livelihood, Right Effort, Right Mindfulness and Right Concentration.

This first sermon is known as 'Setting the Wheel of the Law in Motion' or 'Turning the Wheel of Dharma' (Sanskrit for law, teaching or doctrine). Thus this teaching gesture is known as dharmachakra mudra. Figures of the Buddha teaching often show him seated in what is called the 'European' posture (bhadrasana).

Sandstone sculpture from Sarnath,
India, 5th century AD

44

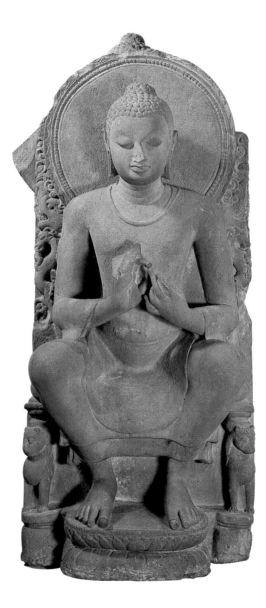

WALKING BUDDHA

After preaching the First Sermon, the Buddha travelled the countryside with his followers, explaining the Middle Way. His teaching took the form of discourses followed by questions and discussions, after which his listeners could make up their own minds. He often spent time among the outcasts of society, and he made use of parables as a way of communicating great truths. He was also credited with working many miracles.

Hearing of Shakyamuni's Enlightenment, his father Shuddhodana sent a message asking him to return to Kapilavastu. On arrival his son Rahula came to him, asking for his inheritance. He replied: 'I cannot offer you gold and jewels, but I can give you spiritual treasures.' Rahula was ordained a monk, and when women were later admitted to ordination, Shakyamuni's wife Yashodhara and his nurse Prajapati both became nuns.

Figures of the Buddha walking were first developed by the metalworkers of Sukothai in Thailand in the thirteenth century AD. They stress the active aspect of the Buddha's ministry and convey his accessibility in the way the Buddha seems to approach the viewer. In this image, the Buddha's right hand is raised in the gesture of reassurance (abhaya mudra).

Bronze walking Buddha figure
from Thailand, 14th century AD

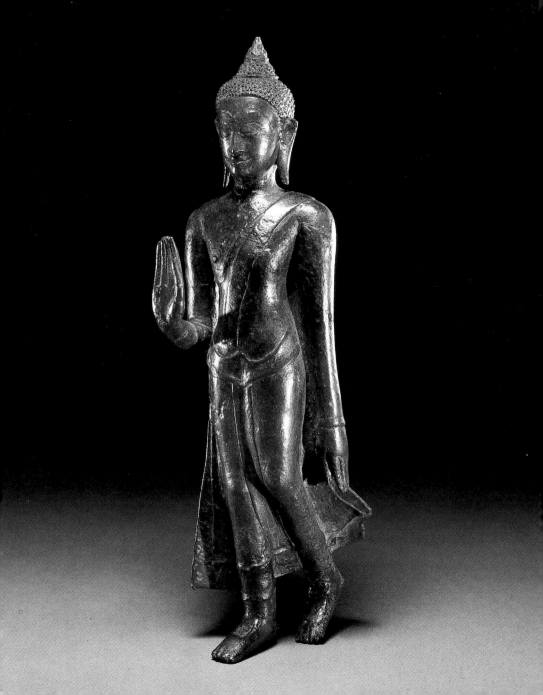

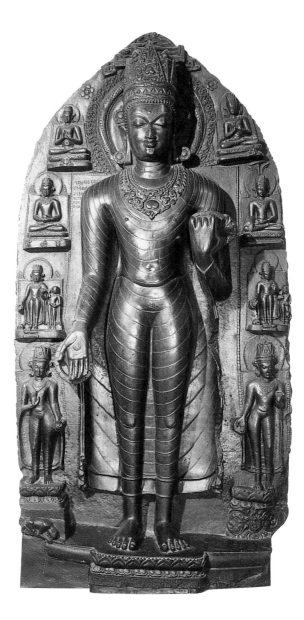

CROWNED BUDDHA

SOON AFTER THE First Sermon the Buddha ascended to heaven, where he preached the Dharma to the gods and to his deceased mother. He then made a triumphant return to earth, accompanied by the gods Indra and Brahma. The large crowned Buddha at the centre of this composition refers to the Descent from Heaven, and this is surrounded by smaller scenes illustrating other episodes from Shakyamuni's life.

The small Buddha seated beside the left shoulder of the central figure is making the earth-touching gesture, recalling his Enlightenment. Above the right shoulder another seated Buddha is making the teaching gesture, representing the First Sermon. Opposite is another teaching Buddha with a small figure kneeling at his feet. This recalls the Miracle at Sravasti, when the Buddha displayed his supernatural powers and won many converts. Above the crown of the central figure, a reclining figure of the Buddha refers to his physical death (mahaparinirvana).

Several of the Buddha's miracles involved animals, sometimes used as symbols of human passions. On both sides of the central figure, the Buddha is shown subduing a wild elephant sent by a rival to attack him. Above one of these scenes is a seated Buddha holding a monk's begging bowl. On the plinth, a tiny monkey refers to an episode when the Buddha accepted a bowl of honey offered by a monkey.

Schist sculpture from Bodh Gaya, India,
11th–12th century AD

DEATH OF THE BUDDHA

ALTHOUGH HE HAD ATTAINED Enlightenment, as a human Shakyamuni had to die. According to tradition, this took place in Kushinagara in India when he was eighty years of age. The physical death of the Buddha is termed mahaparinirvana, the 'great state beyond nirvana'. Shakyamuni became a tathagata – 'one thus gone'.

According to tradition, Shakyamuni departed this life while lying on his right side and supporting his head with his right hand, a position known as the mahaparinirvanasana. His last instruction to his disciples was to 'be a light to yourselves' – once again placing responsibility firmly on the individual. In this relief from a Gandharan stupa, the tranquil form of the reclining Buddha forms a dramatic contrast to the mourning disciples, who are shown in contorted attitudes of grief. Only one monk, mindful of the Buddha's teachings, sits in peaceful meditation.

> *Let a person be a light to himself and learn wisdom.*
> *When he is free from delusion, he will go beyond birth and death.*
> Dhammapada

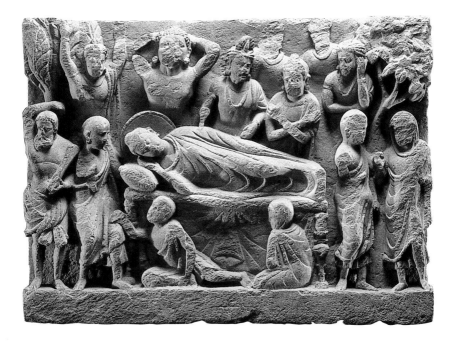

Schist panel from Gandhara,
Pakistan, 2nd–3rd century AD

THE STUPA

IN THE CENTURIES FOLLOWING the Buddha's mahaparinirvana the new faith underwent rapid expansion and change. By the first century AD, Buddhist teachings had spread throughout the Indian subcontinent, to Afghanistan in the north and Sri Lanka in the south. In the second and third centuries it travelled through Central Asia to China and by the fourth and fifth centuries it had reached Burma, Thailand, Korea and Indonesia, finally arriving in Japan between the sixth and ninth centuries.

Wherever Buddhism went, the Buddha's relics were enshrined in stupas as objects of veneration. Stupas evolved in many different forms under various names — in Thailand they are called chedis, in Burma and China pagodas and in Tibet chortens. The Svayambhunath stupa in Kathmandu, Nepal, is close to the original type, with a hemispherical dome; the eyes painted on the tower probably represent the guardian deities of the four cardinal points, who are said to reside there. At the apex is a spire; traditionally this is divided into sections representing the stages on the path to Enlightenment.

Building stupas has always been considered an excellent way to accumulate good karma, so sites such as this are often surrounded by numerous small stupas dedicated by worshippers. These often contain Buddhist texts or the remains of renowned Buddhist teachers. People who cannot afford to build full-scale stupas often dedicate small models or even simple clay plaques stamped with images of stupas.

Svayambhunath stupa,
Kathmandu, Nepal

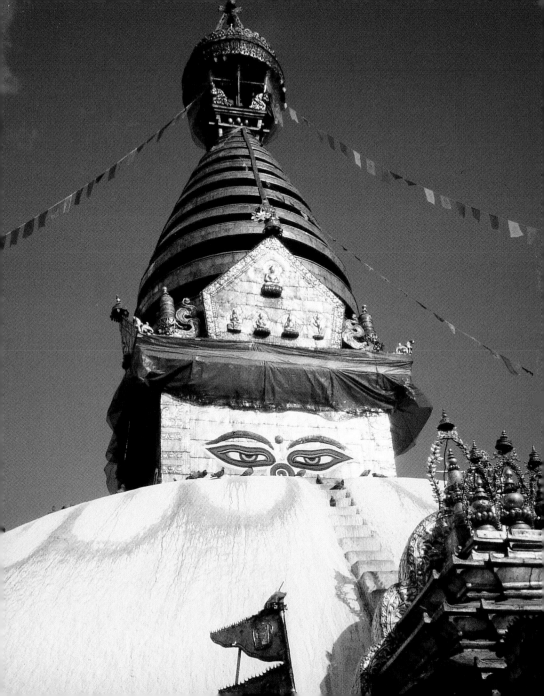

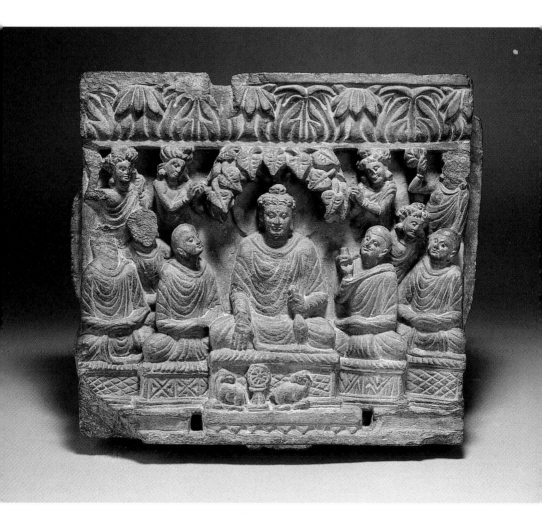

Schist panel from Gandhara, Pakistan,
2nd–3rd century AD

THE THREE JEWELS

T HE FIVE DISCIPLES to whom the Buddha preached the First Sermon at Sarnath formed the core of the first Buddhist community. This relief from Gandhara shows the Buddha surrounded by the five disciples and seated on a plinth above a wheel flanked by deer. The wheel is a symbol of the Dharma, and especially of the First Sermon, its eight spokes representing the Noble Eightfold Path. The deer are a reference to the fact that the First Sermon was preached in a deer park, and a reminder that the Buddhist teachings are intended for the benefit of all living beings.

Taken together, the Buddha, his teaching (Dharma) and the spiritual community (Sangha) are known as the Three Jewels in which Buddhist practitioners place their faith, an act known as Taking Refuge.

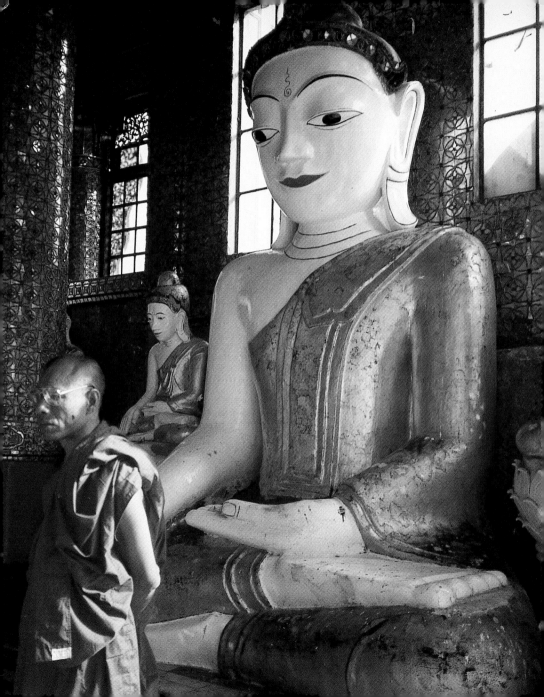

MONASTICISM

Most Buddhist traditions regard the monastic state as an ideal, since a life free of worldly distractions and attachments is considered most conducive to meditation. Settled monasticism began as an annual retreat during the rainy season, when the Buddha's disciples were unable to travel about preaching and begging alms. As permanent monasteries developed, these took on an expanded role as schools and places of lay worship.

Buddhist monks and nuns observe what are known as the Ten Precepts: to abstain from killing, theft, sexual contact, lying, intoxicants, eating after noon, worldly entertainments, personal adornment, luxurious beds and owning property other than what is allowed by the monastic rule. This comprises the barest necessities: a begging bowl, robes, a belt, a razor, a water filter, toothpicks, sandals and a rosary.

Then the Buddha said to his monks: Walk over the earth for the blessing of many, out of compassion for the world, for the welfare and the blessing and the happiness of gods and men.
Vinaya Pitaka

Monk in the prayer hall at the
Shwedagon Pagoda, Rangoon, Burma *Overleaf:* Forest monks, Thailand

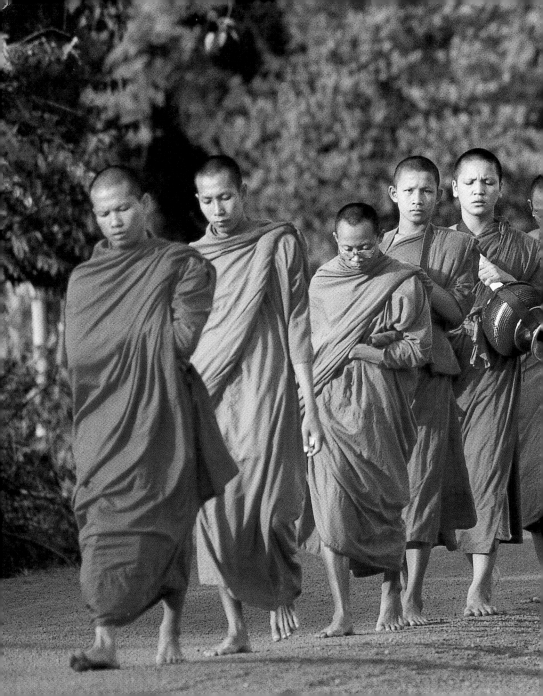

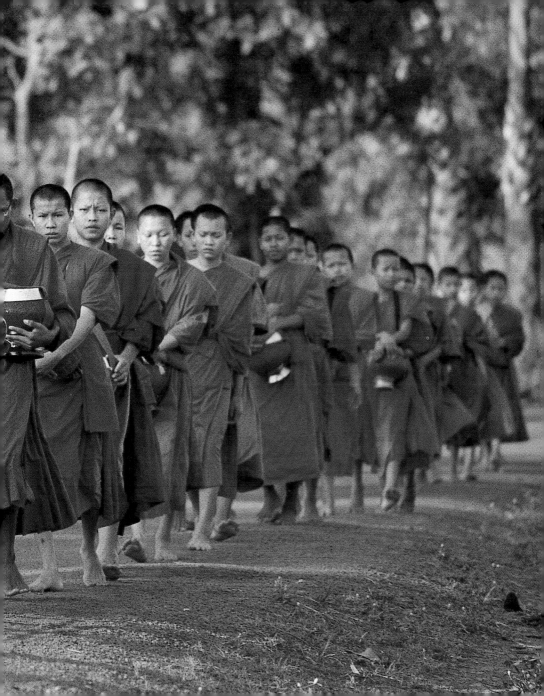

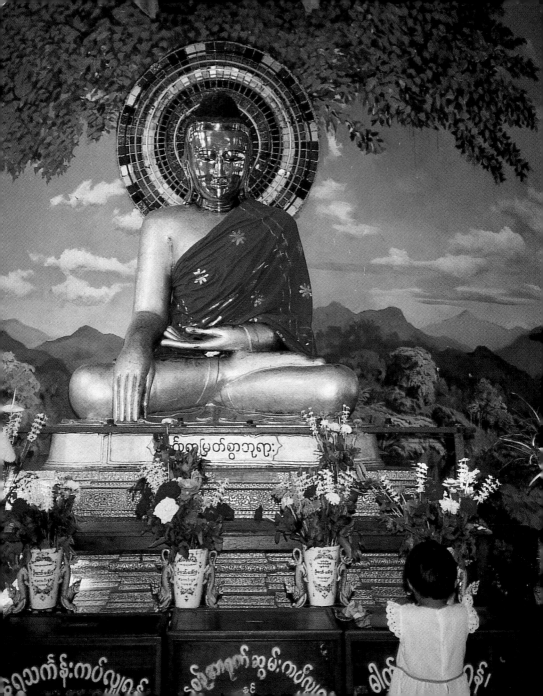

THE BUDDHIST LAITY

A LTHOUGH THE MONASTIC LIFE is seen as the ideal, the lay community also has an important role to play in supporting the Sangha. Lay Buddhists may attain merit by observing several of the Ten Precepts as well as providing material support to the Sangha, endowing Buddhist foundations and paying respect to Buddha relics.

Lay people also visit temples and monasteries in order to receive Dharma teachings, participate in festivals and ceremonies, seek advice from the Sangha, make offerings and pray. Traditional offerings to the Buddha include food, flowers, water, lights and incense; many temples also have collection boxes for the support of the Sangha and other charitable causes.

Better than all the happiness on earth or in heaven, greater than dominion over all the worlds, is the joy of the first step on the Noble Path.
Dhammapada

Shrine in the Kaba Aye pagoda, Rangoon, Burma. Built in AD 1952 for the Sixth Buddhist Congress held in 1954–6, it is dedicated to world peace.

Overleaf: Buddhist temples at Pagan, Burma

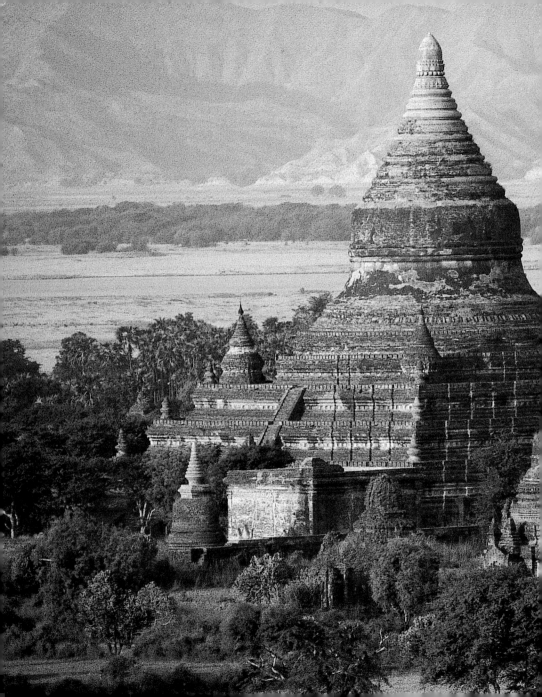

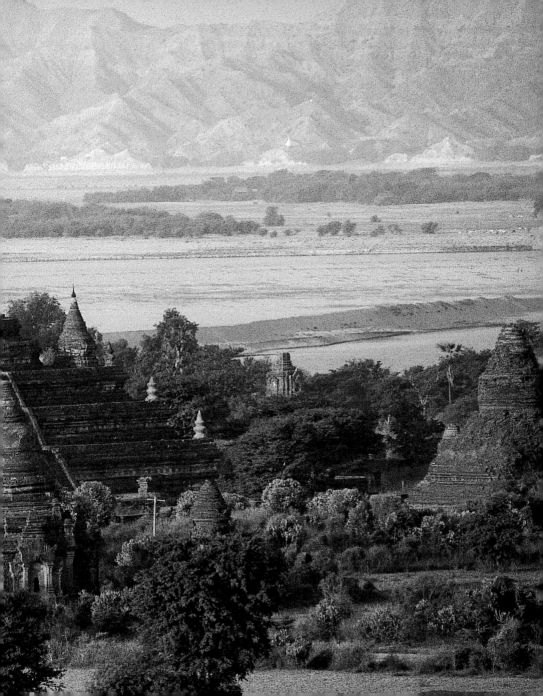

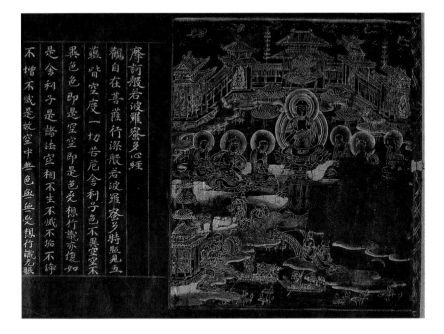

摩訶般若波羅蜜多心經
觀自在菩薩行深般若波羅蜜多時照見五
蘊皆空度一切苦厄舍利子色不異空空不
異色色即是空空即是色受想行識亦復如
是舍利子是諸法空相不生不滅不垢不淨
不增不減是故空中無色無受想行識無眼

Jingo-ji Temple Sutra, Japanese handscroll
painting on indigo paper, Heian period,
mid-12th century AD

64

THE BUDDHIST SCRIPTURES

ONE IMPORTANT TASK for Shakyamuni's successors was the collation of the Buddhist scriptures. These comprised the Buddha's teachings (Sutra), the monastic rules (Vinaya) and the commentaries on these (Abhidharma).

Originally these scriptures were memorized and transmitted orally but then, from about the first century BC, they began to be written down in palm-leaf books using local Indian languages such as Pali. Later these were translated into other languages as Buddhism spread across Asia.

The text itself came to represent the Buddha's speech, just as the rupa or Buddha image is a symbol of his body and the stupa a symbol of his mind. Sacred texts are held in the highest respect and are therefore stored in the highest place in temples. This reverence can also be seen in the use of beautiful calligraphy and bindings.

This manuscript of the Hachi dai-bosatu mandara kyo, or Sutra of the Mandala of the Eight Great Bodhisattvas, was hand-painted in gold and silver on rich indigo paper. The illustration shows Shakyamuni Buddha, surrounded by attendants, explaining the sutra, which describes a mandala with the Buddha at the centre, surrounded by eight Bodhisattvas. Commissioning manuscripts for presentation to temples is a traditional way of accumulating merit, and the two small figures arriving by boat at the bottom of the scene may represent the donors of this text.

PRINTING THE SCRIPTURES

At first, the Buddhist scriptures were painstakingly copied by hand, but the invention of printing in China in the eighth century AD revolutionized the speed with which they could be reproduced and disseminated. By the tenth century, the entire Buddhist canon was available in printed form.

Originally, texts and images were carved on to wooden blocks, which were then inked and pressed on to paper, but this method was superseded in the late sixteenth century with the widespread introduction of moveable type. However, the traditional woodblock printing techniques are still in use in many parts of the world, and devotees often participate in the sponsorship, printing and distribution of Buddhist texts and images as a means of acquiring merit.

Do good things, not for your own sake, but for all the beings in the universe.
Save and liberate everyone you encounter; help them attain the wisdom of the way.
Prajnaparamita (Perfection of Wisdom) Sutra

Monk at Hae'in temple, South Korea,
with one of the temple's 81,137
13th-century wooden printing blocks

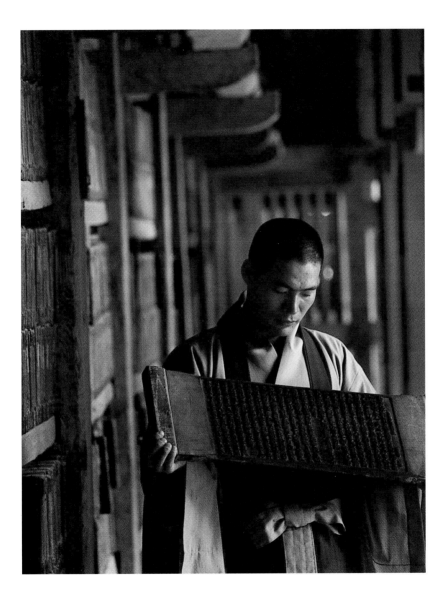

THE TWO SCHOOLS

THE COLLATION OF THE Buddhist canon from a great number of local traditions was not a simple matter, and disputes concerning doctrinal points arose as early as the fourth century BC. By the first century AD, these differences had led to the emergence of the two main Buddhist schools – the Mahayana ('Greater Vehicle') and the Hinayana ('Lesser Vehicle'), known today as the Theravada, the 'Tradition of the Elders'.

The principal difference between the two traditions lies in the Mahayana school's adoption of the Bodhisattva ideal. In the Hinayana tradition, the goal of the practitioner is to achieve Enlightenment in order to attain individual liberation, that is, freedom from one's own suffering. One who has achieved this is called an Arhat, or 'solitary conqueror'.

By contrast, in the Mahayana tradition, although the ultimate goal remains complete Enlightenment, or Buddhahood, the practitioner defers this for the sake of others, aiming instead to become a Bodhisattva – one who has spontaneously generated the motivation to benefit all sentient beings by bringing them to Enlightenment.

In this fourteenth-century manuscript from Korea, the Buddha is shown teaching. The Bodhisattvas, dressed in princely clothes and fine jewellery and distinguished by their halos, represent the Mahayana tradition, and the shaven-headed Arhats behind them the Hinayana.

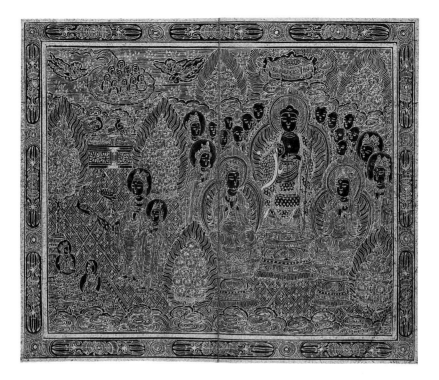

Detail from a frontispiece to an illuminated
manuscript of the Amitabha Sutra from Korea,
Koryo dynasty, AD 1341

THE SUPREME BUDDHA

As Buddhism spread throughout Asia, Buddhist artists naturally drew on their own local traditions, developing their own conventions and iconography. In terms of art, the main difference between the Mahayana and Theravada (Hinayana) schools lies in the relative status accorded to Shakyamuni and other Buddhas. Followers of the Theravada tradition, which predominates in Southeast Asia and Sri Lanka, place great emphasis on the life and deeds of Shakyamuni, and most Buddha images from these regions represent him. In India, Nepal, Tibet, China, Korea and Japan, where the Mahayana school has predominated, Buddhas other than Shakyamuni are often represented.

As well as the Buddhas of the past, present and future, some Mahayana schools recognize a supreme or 'primordial' Buddha, or Adibuddha, who is known by many names including Vajrasattva and Vajradhara. The Adibuddha is regarded as self-emanating and as the true source of all that exists, including the other Buddhas.

In contrast to Shakyamuni, the historical Buddha, the Adibuddha is always shown crowned and ornamented. He can be recognized by the thunderbolt (vajra) in his left hand and the upturned bell (ghanta) in his right. These represent the twin qualities of wisdom and compassion that must be cultivated in order to achieve Enlightenment. Vajradhara, seen here, holds them crossed over his chest, while Vajrasattva is represented holding the thunderbolt to his heart and the bell to his left hip.

Gilt-bronze figure of Vajradhara,
inlaid with silver and copper,
from Tibet, 15th–16th century AD

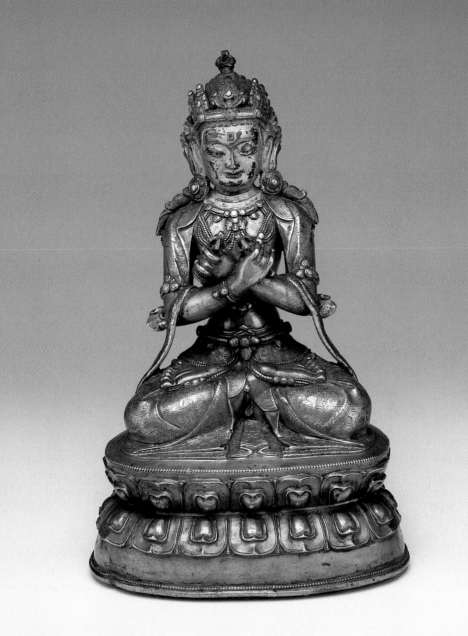

THE COSMIC BUDDHAS

In Mahayana cosmology, the five directions (north, south, east, west and centre) are associated with the five 'cosmic' or Dhyani Buddhas. The cosmic Buddhas may appear together or separately, depending on the context. They are the heads of the five Buddha 'families' to which the Bodhisattvas belong, and each represents a specific aspect of the Buddhas' wisdom.

Ratnasambhava is the Buddha of the South: yellow in colour, his symbol is a wish-granting jewel and his gesture is varada mudra, symbolizing giving. He is the head of the Ratna or Jewel family, characterized by generosity.

Akshobya's emblem is the thunderbolt or vajra, and he makes the earth-touching gesture bhumisparsha mudra; thus he is associated with Shakyamuni's victory over desire. He is the Buddha of the East and the head of the Vajra family, characterized by immovability and resolve.

Vairochana, the white Buddha of the Centre, makes the teaching gesture or dharmachakra mudra associated with the first teaching of the Buddhist Law; in keeping with this, his symbol is the Dharma wheel. He is the head of the Tathagata or Buddha family, characterized by the quality of illumination.

Amitabha is the Buddha of the West, his colour is red and his symbol is the lotus, since he is the head of the Padma or Lotus family, associated with compassion. His gesture is the dhyana or meditation mudra.

Amoghasiddhi is the Buddha of the North: green in colour, his emblem is the powerful double vajra and his gesture is the abhaya mudra, indicating fearlessness; he is the head of the Karma or Action family.

Painted wooden book cover from Tibet,
16th–17th century AD

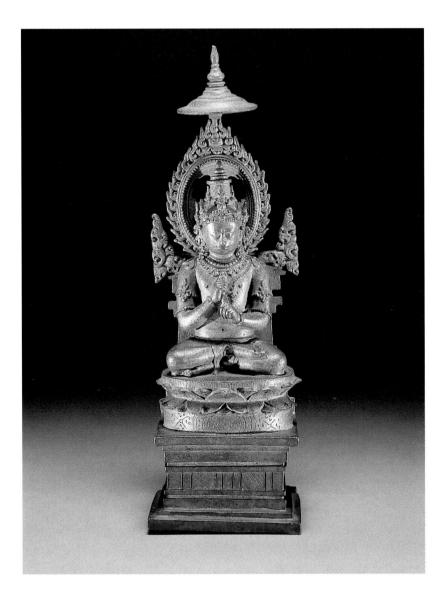

VAIROCHANA

VAIROCHANA, THE COSMIC Buddha of the Centre, is worshipped in many forms throughout the Buddhist world and is sometimes identified with the Adibuddha. In Japan he is revered as the Great Solar Buddha.

As depicted in this bronze figure from Java, Vairochana sits in the cross-legged vajrasana posture, his right foot resting on his left thigh, and makes the dharmachakra mudra or teaching gesture. He is shown crowned and ornamented, and his head is ringed by a fiery aureole crowned with a parasol.

Of all the world and all the worlds of gods,
this only is the Law: that all things are impermanent.
BUDDHIST PARABLE

Bronze figure from Java,
10th century AD

AKSHOBYA MANDALA

BUDDHISM TEACHES THAT the world as we experience it is an illusion. In reality, nothing has an independent existence; all phenomena arise from and return to a state of non-being, or Emptiness (shunyata). In Buddhist art this is illustrated by the mandala, a drawing or model representing the universe and its processes.

A mandala is organized around a central figure or sacred symbol from which it emanates; this is surrounded by concentric enclosures occupied by deities or symbols. This bronze mandala from eastern India is in the form of a lotus flower, an important Buddhist symbol representing purity and perfection: just as a pure lotus flower has its roots in the mud and filth of the riverbed, so a Buddha has transcended the mire of physical existence to attain Enlightenment.

The central figure is the cosmic Buddha Akshobya, seated cross-legged with his symbol, the thunderbolt (vajra), on the ground in front of him. Standing on the lotus petals around him are eight figures of Bodhisattvas. The petals of the mandala open and close to demonstrate how phenomena arise from and return to Emptiness.

Bronze mandala with silver and copper inlay
from eastern India, 12th century AD

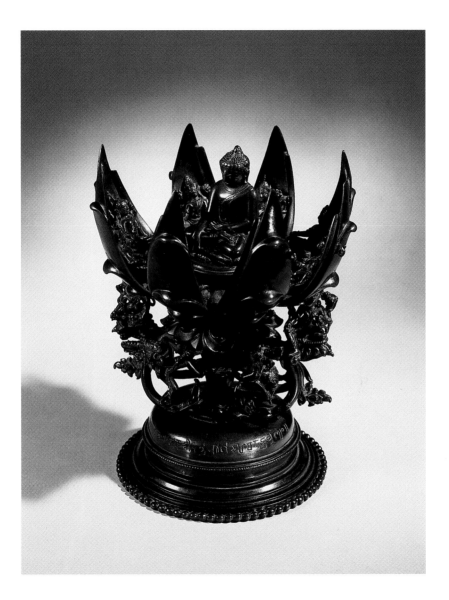

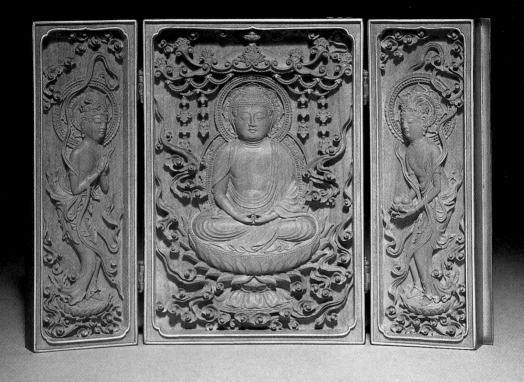

Lacquer shrine from Japan,

c. AD 1920

AMITABHA

AMITABHA, THE BUDDHA of the West – known as Amida in Japan and Opame in Tibet – is by far the most commonly represented of the cosmic Buddhas because of his association with paradise and the afterlife.

According to the Mahayana school, each of the Buddhas presides over his own Pure Land, a kind of heaven where the faithful devotee can be reborn after death. Amitabha's Pure Land is known as the Western Paradise, or Sukhavati. In the Pure Land schools of Mahayana Buddhism, the practitioner gains admission to Sukhavati through devotion to Amitabha, especially through repetition of his mantra, a series of Sanskrit syllables that simultaneously invoke, praise and embody him. The simplicity of this practice holds great appeal for lay Buddhists and is especially popular in Japan and China.

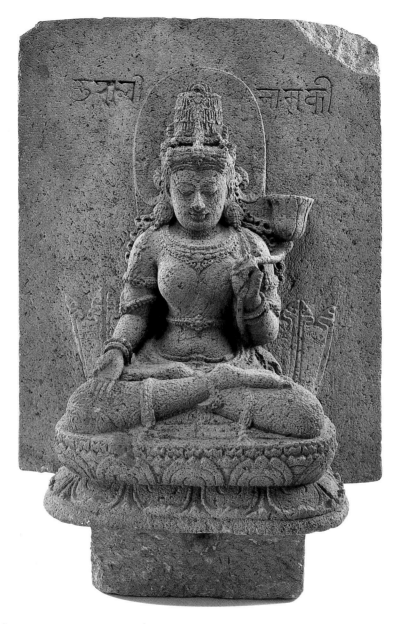

FEMALE BUDDHAS

REFLECTING THE SUBORDINATE status of women in the ancient cultures of Asia, Buddhist imagery tends to be overwhelmingly masculine. However, some schools of the Mahayana tradition do recognize female Buddhas, though they are only rarely represented in art.

The best known female Buddhas are the counterparts or consorts of the cosmic Buddhas, representing the Buddhas' wisdom, which is perceived as a 'feminine' quality complementing the 'masculine' quality of compassion.

This Javanese image represents Mamaki, the partner of Ratnasambhava, the Buddha of the South. Like him, she sits in the cross-legged meditation posture and makes the gesture of generosity with her right hand, while holding a lotus in her left. It may have come from the southern face of a Javanese stupa like that at Borobodur, where the terraces form a mandala of the universe.

Volcanic stone figure
from Singahsari,
Java, 13th century AD

Overleaf: The Potala palace in Lhasa, Tibet,
traditional residence of the Dalai Lamas

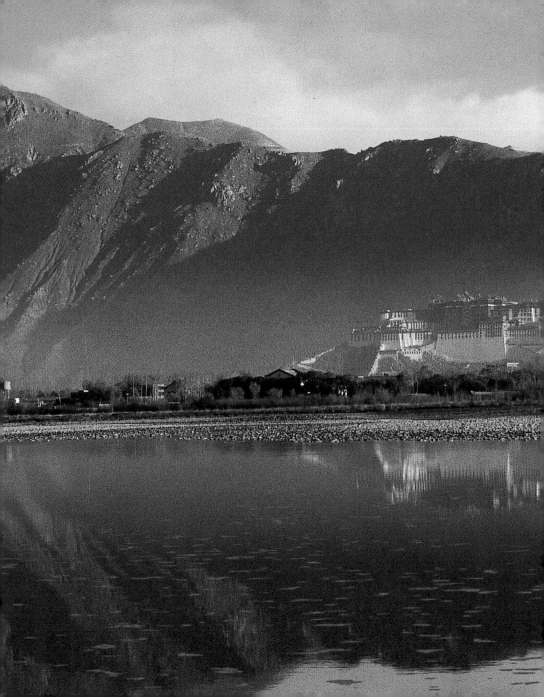

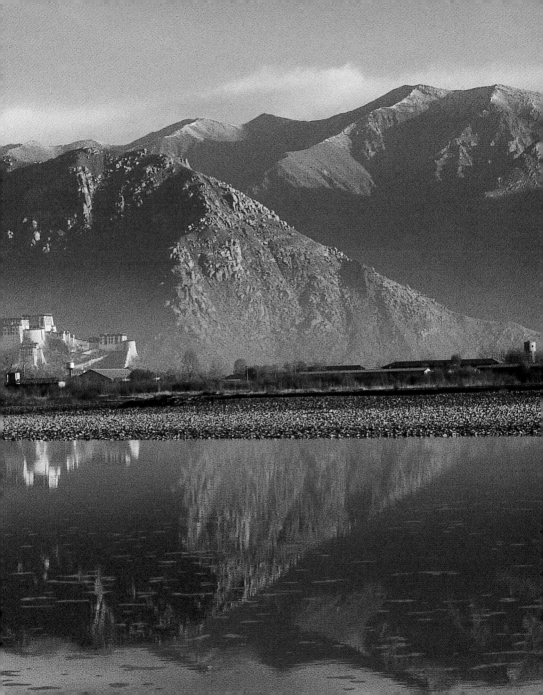

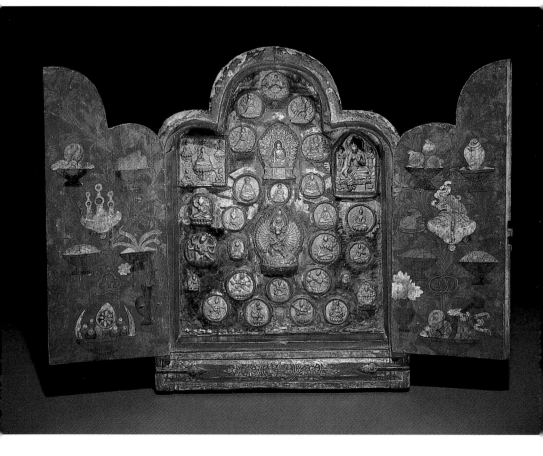

Painted wooden shrine from Tibet,
19th century AD

THE VAJRAYANA SCHOOL

T HE VAJRAYANA or 'Thunderbolt Vehicle', a school of Mahayana Buddhism, appeared from about the fourth century onwards. It is also known as Tantric Buddhism because it is based on esoteric teachings known as tantras.

These very powerful teachings offer a rapid route to Enlightenment by means of intensive forms of mental training including physical discipline, visualization and mantra recitation. A mantra is a series of sacred syllables that simultaneously invokes, praises and embodies the Buddha or Bodhisattva on whom the practitioner is meditating. Reciting or writing mantras is considered an act of great merit and a means of purifying karma. Some tantras guarantee the attainment of Buddhahood within a finite number of lifetimes – in some cases a single lifetime – if practice is regularly maintained.

The best-known Vajrayana traditions are found in Tibet and Nepal, but they also exist in Bhutan, Mongolia, China, Japan and Korea. This portable shrine from Tibet illustrates the vast number of Buddhas, Bodhisattvas and saints recognized by the Vajrayana school. The central image of Shakyamuni is surrounded by small plaques (tsa-tsa) of Buddhas, Bodhisattvas, Dharma teachers and sacred symbols. The doors are painted with images including jewels, elephant tusks, treasure vases, flowers, fruits, musical instruments and other auspicious objects which serve as offerings to the holy beings represented inside.

Overleaf: Stones inscribed with Buddhist mantras, Dharamsala, India

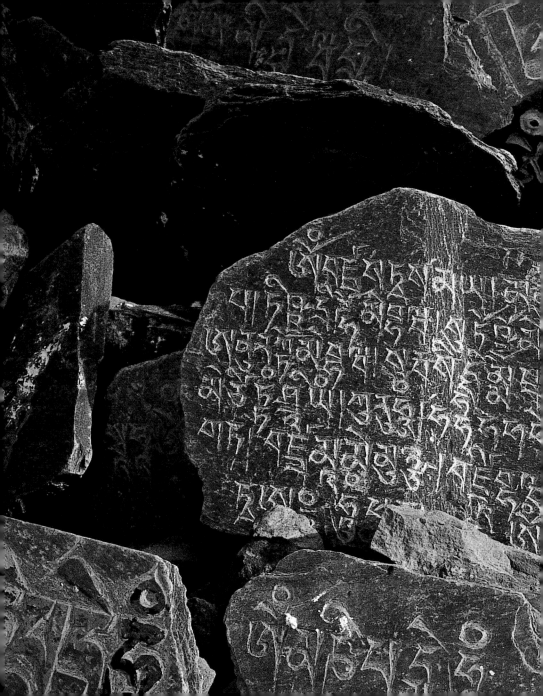

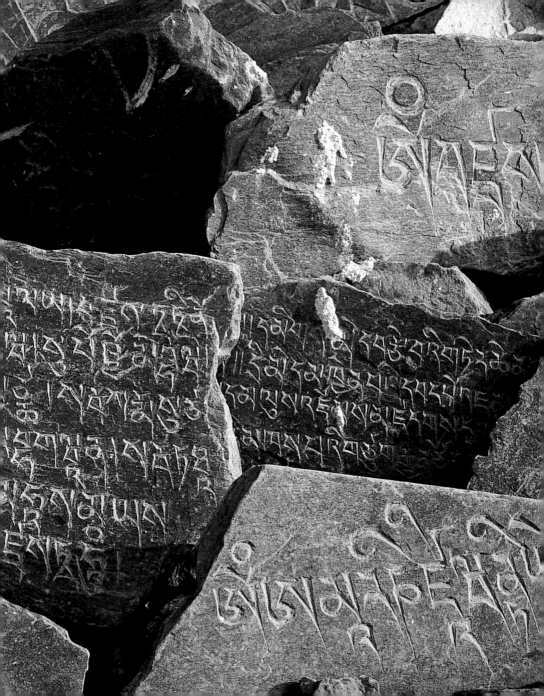

THE TEN WORLDS

I N ADDITION TO THE SIX REALMS of samsara, this seventeenth-century Japanese diagram of the Ten Worlds shows the four routes of liberation from the cycle of rebirth: the paths of the Buddha, the 'Silent Buddha' or Pratyekabuddha (a Buddha who does not teach), the Bodhisattva and the Arhat. At the centre is the character for 'heart', indicating that this is where practitioners should seek their means of liberation.

The text accompanying the diagram explains the Avatamsaka Sutra for the lay reader, describing how each of the Ten Worlds contains all the others. As well as providing a visual image for contemplation, the diagram serves as an aid to study and devotion. Each time the practitioner completes 10,000 recitations of the sutra, he or she can fill in one of the circles outlining and dividing the image. When all have been filled in, enough merit will have been accumulated to guarantee rebirth in a Pure Land, or Paradise.

Hand-coloured woodblock print
from Japan, AD 1669

観心十方界圖

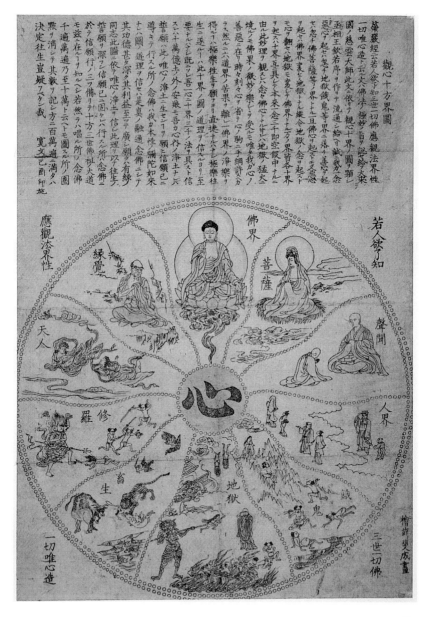

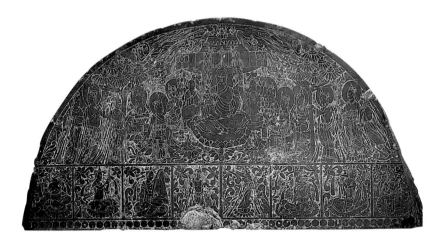

Stone door lintel from China, Sui or
early Tang dynasty, 6th–7th century AD

THE PURE LAND

IN THE PURE LAND, all material needs are met and conditions are perfect for receiving the Dharma teachings continually provided by the presiding Buddha. Those beings fortunate enough to be reborn into a Pure Land are thus guaranteed to attain Enlightenment in the future.

This stone lintel representing the Pure Land probably came from above a Chinese pagoda entrance, where it would have been placed to inspire visiting worshippers. At the centre, a Buddha sits on a lotus throne beneath an elaborate canopy. With his left hand he makes the gesture of explaining the Dharma (vitarka mudra). He is surrounded by an audience of Arhats and Bodhisattvas who have assembled to hear his teachings, while at his feet two newborn souls emerge from lotus flowers. Beneath them is a panel showing dancers and musicians.

The sun shines by day, and the sage shines in his wisdom.
The moon shines by night, and the sage shines in contemplation.
But day and night, the enlightened shine in radiance of the spirit.
Dhammapada

THE FUTURE BUDDHA

MAITREYA, WHOSE NAME means 'Friendship' or 'Benevolence', is the next Buddha, said to be residing currently as a Bodhisattva in the Tushita Heaven. He is recognized by all Buddhist traditions, including the Theravada.

It is believed that Maitreya will first appear on earth at Bodh Gaya, where he will be enshrined by Shakyamuni as his successor. According to some traditions, he will break open a stupa containing the past Buddha Kashyapa, who has been waiting inside for his coming.

Maitreya may be shown as a Buddha or as a crowned and ornamented Bodhisattva. Images of Maitreya can be identified by a small stupa in his hair, and he often holds a flask or vase said to contain the elixir of life.

Drink deeply, live in serenity and joy.
The wise person delights in the truth and follows the law of the Awakened.
Dhammapada

Gilt-bronze figure from China,
Liao dynasty, 11th century AD

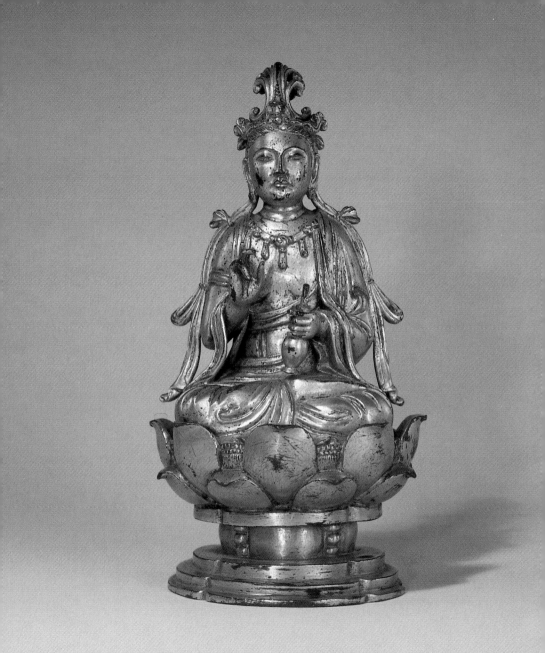

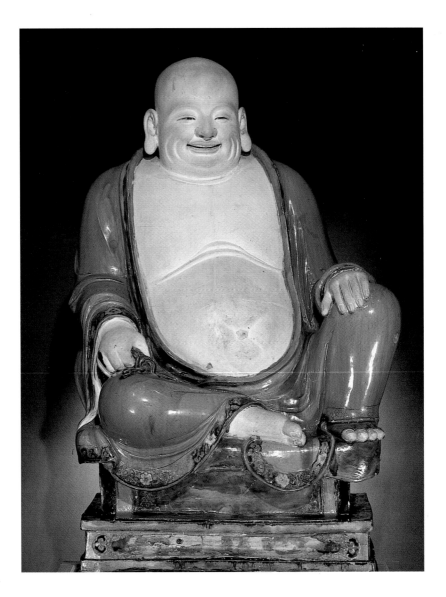

THE LAUGHING BUDDHA

THE POPULAR FIGURE of the Laughing Buddha is well known throughout the world, especially among Chinese and Japanese communities. Regarded by some Buddhist schools as a form of the future Buddha Maitreya, he embodies a number of folk traditions found in popular Buddhism.

Known as Budai in China and Hotei in Japan, the Laughing Buddha is represented as a Mahayana monk with a bald head, large belly and broad smile. He leans on a large sack full of inexhaustible treasures and is sometimes regarded as a god of prosperity.

Figures of the Laughing Buddha are often placed near temple entrances to welcome worshippers. In Chinese temples he is sometimes accompanied by the Good Boy and the Bad Boy, judges of the dead who decide whether to send the soul of a dead person to heaven or hell. Some images of the Laughing Buddha show him with numerous small children clambering over his body; in Japan, small models of Hotei are made as toys.

May all beings be happy,
May they live in safety and joy.
Metta Sutta

Stoneware figure of Budai
from Henan province, China,
Ming dynasty, dated AD 1486

FURTHER READING

Bechert, H. and Gombrich, R., eds, *The World of Buddhism*, London, 1984

Conze, E., *A Short History of Buddhism*, London, 1982

Knox, R., *Amaravati: Buddhist Sculpture from the Great Stupa*, London, 1992

Kornfield, J., ed., *Teachings of the Buddha*, Boston and London, 1993

Rowland, B., *The Evolution of the Buddha Image*, New York, 1968

Seckel, D., *The Art of Buddhism*, London, 1964

Snellgrove, D. L., *The Image of the Buddha*, Paris and London, 1978

Whitfield, R. and Farrer, A., *Caves of the Thousand Buddhas: Chinese Art from the Silk Route*, London, 1990

Zwalf, W., ed., *Buddhism: Art and Faith*, London, 1985

Zwalf, W., *A Catalogue of the Gandhara Sculpture in the British Museum*, 2 vols, London, 1996

ILLUSTRATION REFERENCES

British Museum objects (indicated BM) appear by courtesy of The Trustees of The British Museum and the Department of Photography and Imaging.

page					
2	BM, OA 1982.3-31.1	31	BM, OA 1919.1-1.096	62–3	Photograph by Graham Harrison
5	Photograph by Bryn Jones (http://purple.nd.edu.au/coms/bj/buddha)	32	BM, OA 1880-227	64	BM, JA 1958.5-10.03
		35	BM, OA 1919.1-1.096	67	Photograph by Graham Harrison
		37	BM, OA 1996.10-3.02		
		38	BM, JA 1891.9-5.20	69	BM, OA 1983.10-8.01
6	BM, OA 1938.7-15.1	41	BM, OA 1908.4-20.4	71	BM, OA 1979.5-14.1
9	BM, OA 1945.4-19.1	42	Photograph by Graham Harrison	73	BM, OA 1938.5-26.1
11	BM, OA 1898.6-22.23			74	BM, OA 1859.12-28.77
12	Photograph by Graham Harrison	45	BM, OA 1880-7	77	BM, OA 1982.8-4.1
		47	BM, OA 1947.5-14.1	78	BM, OA 1945.10-17.488
15	BM, OA 1880.7-9.79	48	BM, OA 1872.7-1.30	80	BM, OA 1859.12-28.171
17	BM, OA 1880.7-9.57	51	BM, OA 1913.11-8.17	82–3	Photograph by Graham Harrison
19	BM, OA 1900.2-9.1	53	Photograph by Delia Pemberton		
20	BM, OA 1905.6-16.83,89	54	BM, OA 1979.1-30.1	84	BM, OA 1954.2-22.8
22–3	Photograph by Delia Pemberton	56	Photograph by Delia Pemberton	86–7	Photograph by Graham Harrison
25	Photograph by Graham Harrison	58–9	Photograph by Graham Harrison	89	BM, OA 1931.5-13.029
				90	BM, OA 1937.7-16.1
27	BM, OA 1919.1-1.096	60	Photograph by Delia Pemberton	93	BM, OA 1959.7-13.1
29	BM, OA 1912.12-21.1			94	BM, OA 1937.1-13.1